george
nelson

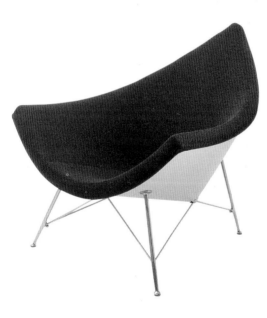

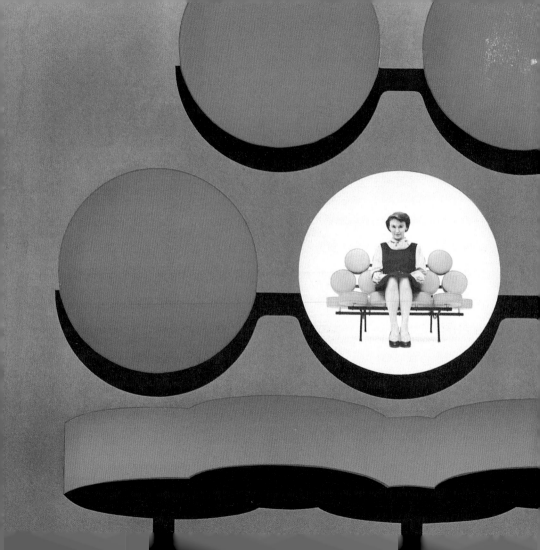

COMPACT 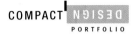 DESIGN
PORTFOLIO

george
nelson

BY MICHAEL WEBB
EDITED BY MARISA BARTOLUCCI + RAUL CABRA

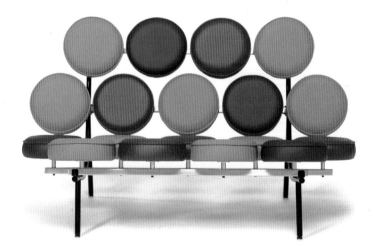

CHRONICLE BOOKS
SAN FRANCISCO

NK
1412
.N45
W43
2003

COVER: HERMAN MILLER PLATFORM BENCH, 1946
BACK COVER: SUNBURST CLOCK REISSUED BY VITRA, 1999;
SUNBURST CLOCK SKETCH, 1950s
PAGE 1: HERMAN MILLER COCONUT CHAIR, 1955
PAGE 2: HERMAN MILLER AD, 1956
PAGE 3: HERMAN MILLER MARSHMALLOW LOVE SEAT, 1956
PAGE 6: HERMAN MILLER *ARCHITECTURAL RECORD* AD, 1961

ABOVE: MINIATURE CABINET ON PEDESTAL FOR HERMAN
MILLER, 1954

Acknowledgments

Profound thanks to Herman Miller, Inc., and especially to Robert W. Viol, corporate archivist; Linda M. Baron, photographic archivist; and Mark W. Schurman, director, external communications; for their warm hospitality in Zeeland and for generously providing photographs and transcripts, as well as answering many questions. The Herman Miller Archives are a marvel! Deep appreciation to Vitra Design Stiftung GmbH, for Rolf Fehlbaum's generous support and Andreas Nutz's extraordinary industry in selecting images from the George Nelson Archives. Nelson veterans Irving Harper, John F. Pile, and George Tscherny shared their vivid memories, as did Ralph Caplan, John Berry, Roger Bush, and Calvin Rotman. My gratitude to the curators who showed me vintage Nelson pieces: Christel Guarnieri at the Los Angeles County Museum of Art; Hank Prebys at the Henry Ford Museum, Dearborn; Kathleen Ferris at the Grand Rapids Art Museum; and Christian Carron at the Grand Rapids Public Museum. Michael Darling kindly allowed me to read his unpublished UCSB thesis on the domestic furniture designs of the George Nelson Office, and to quote a few of his perceptive insights. I was inspired by Stanley Abercrombie's admirable biography, *George Nelson: The Design of Modern Design*, and by the extraordinary writings of George Nelson himself. For the exemplary design of this volume, my deep gratitude goes to Betty Ho at Cabra Diseño. Above all, I thank my editor, Marisa Bartolucci, and Chronicle editor, Alan Rapp, for giving me the opportunity to share my enthusiasm for one of the giants of twentieth-century design.

George Nelson
The Diaghilev of Design By Michael Webb

George Nelson's long, productive life (1908–86) encompassed the birth, heyday, and decline of American Modernism. He made a major contribution to that movement as a writer, advocate, social critic, impresario, and architect. He was "an original thinker," observes design critic Ralph Caplan, "with a gift for communicating ideas and finding good people. His office had a consistency of thoughtfulness, even when it was whimsical or humorous." Nelson's associate, designer Bruce Burdick, agrees: "George was a unique person who will be remembered for his thoughts and writings about design. His words were more important than the projects."

As design director for Herman Miller from 1945 through the mid–1960s and later as an outspoken consultant, Nelson found what he called "a glorified cabinet shop" and helped make it an industry leader, a powerhouse of modern residential and contract design. He was passionately involved with this family firm over four decades, sharing the spotlight there with Charles and Ray Eames, Alexander Girard, and, briefly, Isamu Noguchi. He brought these designers to them because he wanted nothing but the best and, as he explained, "I can't have all the ideas."

"It scared the daylights out of me to pull Charlie into that act because I knew that, if I lived forever, I never could turn out stuff like those chairs he did," Nelson confessed. "I realized it was absurd for me to be director of design because no one was going to direct Charlie."[1]

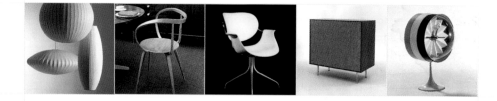

Nelson and Charles Eames were almost exact contemporaries and were often as close as siblings, sharing a passion for excellence and a loathing for compromise and expediency. Communicating ideas was another bond, and they collaborated seamlessly (with the enthusiastic participation of Alexander Girard) on a multimedia educational experiment. First presented at the University of Georgia in 1953 and reprised at UCLA the following year, "A Rough Sketch of a Sample Lesson for a Hypothetical Course" was a one-hour sensory extravaganza that has become the stuff of legend. Students were electrified: one exclaimed to Nelson, "All teaching should be like this."

Although Nelson consistently supported the Eameses, he sometimes resented the fact that they won more respect than he. It's easy to see why this happened. The Eames Office designed chairs and tables that resolved basic issues and never went out of style. They solved problems on an abstract level and took as long as they needed to get things right. The Nelson office was under pressure to respond to immediate needs, and their problem solving often focused on instruments of daily life that have changed over the years, such as typewriters, record changers, and Dictaphones. These are now historic artifacts, and the desks and cabinets designed for them are material for a time capsule.

Every design aficionado is familiar with the Nelson classics: the platform bench, Marshmallow love seat, Coconut chair, Sling sofa, ball clock, and

bubble lamps. However, Nelson was personally responsible for only the first of these and an early prototype of the last. As head of his own design office he handpicked brilliant talents and gave them the freedom to develop his ideas in their own way and to work independently on the design of furniture, graphics, clocks, lamps, exhibitions, interiors, an experimental house, and much else. That freed him to meet with clients, deliver lectures, organize a new approach to art education, conceptualize an exhibition, plan another Aspen design conference, or do what he loved best—write.

Irving Harper, a former associate of Gilbert Rohde and Raymond Loewy, who joined the office in 1947 and was Nelson's principal associate for seventeen years, told architecture curator Michael Darling: "George was heavily involved with the first group of furniture, but after that his involvement was more minimal. He used to dream aloud about designs, and his ideas were mostly verbal. George was a great design head, but to call him a great designer is inaccurate and unfair to the other designers in the office. I would call him a Diaghilev of design."[2]

Nelson was happy to admit the debt he owed his colleagues, though the practice of the time was to credit the head of the firm for everything that emerged from the office. He was one of a handful of American designers—Raymond Loewy, Charles and Ray Eames, Henry Dreyfuss were others—whose names were celebrated and highly salable. In his later years, Nelson seems to have lost interest in product design, though it continued to subsidize his speculative ventures. "If I had my druthers, [writing] would be the number one activity and the other stuff would be number two," he told design curator Mildred Friedman.[3] "I find I'm getting more and more interested in why things are and what the meaning of this and that is, and much less intrigued by the quality of an object, although I like looking at them." He joked that his parents had always wanted him to be a writer, and in the final analysis, they won.

Everything Nelson did seemed to happen by chance. Born in Hartford, Connecticut, to arts-loving parents of Russian Jewish ancestry, he went to Yale with little idea of what he would do with his life, chanced on an exhibition of Beaux Arts sketches, and decided on impulse to study architecture. He taught himself to draw, graduated, and began what he expected would be a teaching career. Laid off at the beginning of the Depression, he went flat out to win the Paris Prize (a prize offering fellowships and residencies), and, though he failed, the momentum brought him the Rome Prize and a two-year scholarship to study at the American Academy there.

While in Europe he met and interviewed several leading modern architects, starting with Le Corbusier, and on his return to America, Nelson sold his essays to *Pencil Points* magazine, supplying a convincing facsimile of the drawings the French master failed to deliver. Those sharply observed profiles led to an editorial post at *Architectural Forum.* In partnership with architect William Hamby, he designed a radical town house for airplane builder Sherman Fairchild on the upper east side of Manhattan. During the war he taught at Columbia and sketched "Grass in the Streets"—a concept that anticipated the pedestrian shopping mall. **He took on a special project at *Fortune*, another Henry Luce magazine, where he designed the slatted platform bench as a way of deterring callers from sitting in his office for more than fifteen minutes. It failed that test, but became a durable icon; the foundation of another career.**

Toward the end of the war, he and Henry Wright, his coeditor at *Forum,* wrote a book, *Tomorrow's House,* proposing innovative solutions to everyday needs. Unable to meet his deadline for a chapter on storage, he conceived the Storagewall—an expansion of an ordinary cavity wall to contain all the impedimenta of daily life. This seminal design was published in *Forum* and later in a splashy *Life* feature, provoking wide public interest and intense hostility from the furniture trade press, which feared that the invention could ruin the case-goods industry.

Those articles excited the interest of Herman Miller president D. J. DePree, a devout Calvinist with a firm belief in providence and honesty. In 1930 sales of heavy reproduction furniture were lagging, and the firm, located in Zeeland, Michigan, faced bankruptcy. Gilbert Rohde, a New Yorker who had picked up on European trends in his mid-forties, urged DePree to switch to Modernism and fabricate the clean-lined designs he would supply, arguing that applied ornament and faux historicism were dishonest. He won his case, and the struggling company achieved a unique reputation.

In 1944 Rohde died and DePree was shocked by the mediocrity of the furniture experts who applied to take his place. Hoping for another stroke of providence, he invited Nelson to dinner at a Detroit hotel and gave his associates a glowing report of the meeting: "He is recognized among the architects; has a splendid background; is thinking well ahead of the parade; does not want to be limited to the use of wood in planning furniture; believes that more and more units will be built into the house but that a manufacturer of a line such as we have will not suffer for a long time to come . . . Although I haven't seen any of his work I am convinced he is a star in at least some of the things he is doing."[4]

Nelson protested that he knew nothing of the business and had many other projects on his plate. The long-distance courtship continued until letters of agreement were exchanged in summer 1945. He would be paid $20 for each drawing that was accepted and a 3 percent royalty on the sale of pieces he designed. All other aspects of the agreement were founded on trust; there was never a formal contract. Later, Nelson wrote that he "was trained as an architect and found himself in the field of furniture design as a result of a series of accidents, most of which appear to have been caused by an acute dislike for specialized activity."[5]

In fact he was never busier or more focused than during the first eighteen months of his association with Herman Miller. Moonlighting from his jobs with Luce, he collaborated with Ernest Farmer, a German-born cabinetmaker who had worked with Rohde. "I was busy making doodles of stuff I thought we ought to take a pass at," Nelson explained. "Then Ernest would draw them up."[6] The new pieces would be "honest, knock-down, and versatile," as he explained in one of a flurry of memos to Zeeland. His industry was astounding, and when he did take time off he reassured an anxious DePree that he had left Farmer with a stack of assignments. He urged the company to add sales outlets; to run advertisements; and to exploit the latest developments in formed plywood, plastics, and metals. He proposed that Herman Miller consider producing lamps, fabrics, and accessories to set off its furniture and generate additional revenue. Top photographers should be commissioned to shoot new products and room settings.

The revolutionary nature of these proposals, many of which were accepted, became clear when Nelson's report on the furniture industry appeared in *Fortune*. With characteristic chutzpah he had let the magazine subsidize the research he needed to do for his new job, and his conclusions devastated the American furniture industry, based largely in Grand Rapids, Michigan, and High Point, North Carolina. He characterized their product as "endlessly and unnecessarily varied and almost uniformly uninspired." He described a craft industry of 3,500 firms that was wedded to wood, traditional styles and techniques, and tyrannized by ignorant retailers. "Whenever furniture is criticized, the public is blamed. 'When they want something better,' runs the refrain, 'we'll be only too glad to make it for them.' **The average manufacturer has no convictions whatever about design, or any understanding of it. Today he is making a lot of 'eighteenth-century'—tomorrow, if he believed it would sell, he would cheerfully switch to Turkish Bordello."[7]**

Rationalism was Nelson's religion, and his faith in the ameliorative power of Modernism bound the freethinking designer to the pious DePree in a turbulent but enduring relationship. Even before they shook hands he had introduced Noguchi to Herman Miller and urged the company to manufacture the biomorphic coffee table the Japanese sculptor had first designed in 1939 for the house of A. Conger Goodyear, president of New York's Museum of Modern Art. For Nelson, the appeal lay as much in its simplicity—two interlocking pieces of wood supporting a slab of plate glass—as its beauty. At one point he wanted to take on Alvar Aalto, who was looking for a new American distributor; Ludwig Mies van der Rohe, who would quickly be snapped up by Herman Miller's rival, Knoll; and Warren McArthur, who wanted to make a magnesium chair frame. His goal was to explore new techniques and produce pieces that might not sell but would draw attention to the firm as one that was leading the way.

The greatest contribution Nelson made to Herman Miller in those early years was to bring Charles and Ray Eames on board—at a time when they were also considering an association with Knoll. He insisted that DePree visit the first showing of the Eames's molded plywood furniture at the Barclay Hotel in New York, in December 1945, and that they secure distribution rights from the manufacturer, Evans Products. **DePree warned Nelson that he was working with a company that grossed only $450,000 a year and he would have to share royalties. He responded that Herman Miller would soon grow to $2 million—which it did, six years later—and declared, "Make everything that Eames designs and don't show it to me —I don't need to approve it."**[8]

Even as he lined up these stars, Nelson was designing, with Farmer, more than seventy new pieces that would be put on show in early 1947. Most were simple case goods, chairs, and tables, which required no special tooling or technical skills, but each piece was made available in a variety of sizes, woods, and finishes. Nelson's overriding

concern was to eliminate waste, and many pieces have a Shaker-like simplicity and versatility. "We really stood on Rohde's shoulders," and were very ingenious in an eighteenth-century way, he recalled.[9] The platform bench served as a raised base for a variety of cabinets. A side table incorporated a lamp, a planter, and a drawer. Drawers containing serving trays extended from either end of a coffee table, doubling its length. Springs were incorporated into a slim platform daybed that doubled as a sofa. A residential desk had a foldout flap to support a typewriter, a slide-out bin of perforated metal for hanging files, a leather work surface, and splayed steel legs. Nelson recalled it as an oddity, introduced to generate publicity, which became a freak best-seller.

What is remarkable about this collection, which was conceived and produced in less time than it would take to introduce one significant item today, is its coherence and quality. Everything works together—in modular dimensions and understated forms. The beveled edges, detailing of joints, and carefully coordinated pulls added value but also pushed up the price. Architects of that era longed to bring good design to the masses, but their work rarely benefited from economies of scale. As Nelson would later conclude, **"Good design combined with good quality cost more than the large public could afford; furthermore, this large public never showed much affection for modern at any price."**[10]

To promote these designs to the target audience of architects and other professionals, Nelson urged DePree to advertise in *Forum, Interiors,* and other upscale journals, pooling the money that would be spent on small monthly ads to create a few color pages. Irving Harper, Nelson's collaborator, judged his first ad a failure, but it yielded the stylized "M" that has remained Herman Miller's logo for more than fifty years with little change. Harper did all the graphics until the arrival in 1952 of George Tscherny, who

was selected for his experience in cabinetmaking as well as graphic design. "It was the best job I could have had—a terrific opportunity to grow," he recalls. "George was a catalyst and brought his spirit to everything we did. He would toss out ideas and let you take it from there."

Tscherny's ads, which ran in the *New Yorker* as well as the design press, match the best of those produced by the Eames Office in wit, originality, and beauty. His swan song— an invitation to the opening of the Herman Miller showroom in Dallas—featured a cowboy hat casually placed on a side chair. Don Ervin took responsibility for graphics when Tscherny left.

A cash-strapped DePree was also persuaded to splurge on a high-quality cata-log printed on good stock with hard covers, containing measured drawings, and photographs by Ezra Stoller of individual pieces and room settings. No furniture company had ever done such a thing before, fearing that their designs would be ripped off if they provided too much information, but Nelson knew that architects would be impressed by the specifications and the production values—and he was right.

Herman Miller decided to sell the catalog for $3—another first—and today it is a costly collector's item. Nelson contributed descriptions of the furniture and a state-ment of principles. In summary this reads: "What you make is important. Design is an integral part of business. The product must be honest. You decide what you want to make. There is a market for good design." He noted that the goal was a *permanent* collection to meet all the requirements for modern living, designed by architects who related each object to the spaces in which it would be used and the people who would use it. "The problem is never seen in isolation," he observed, "an approach that is more likely to create trends than follow them."[11]

With Nelson there is a constant alternation between magisterial declarations of this sort and spontaneous improvisations. When he opened his first office in mid-Manhattan in 1947, he decided that a Swedish hanging lamp—a silk-covered sphere—would add a touch of class. It was priced far beyond his budget, but when it went on sale he and a colleague dashed to the store only to discover that the shopworn sample was priced at $125—a fortune in those frugal times. As he was gnashing his teeth he remembered a news photograph he had seen of Liberty ships being mothballed by spraying netting with self-webbing plastic. They returned to the office, assembled a wire frame, located the spray company, and put together their own sphere—the seed from which grew the bubble lamps that William Renwick designed in 1952. As Nelson observed, "The creative act is always *finding* something."[12]

In 1947 the Howard Miller Company (launched by Herman Miller's brother on a neigh-boring site) wanted to expand its clock collection, and Harper designed the first dozen of a hundred or so wall and table models that he would eventually do for the firm. Inspired by progressive wristwatches, he omitted the numbers, creating the starburst, asterisk, and ball faces that have become modernist icons and have been reissued by Vitra. He also found time to design chinaware for Walker, stacking melamine table-ware in bright colors for the oddly named Pro-Phy-Lac-Tic Brush Company, as well as lamps, typewriters, and printed fabrics. "We were card-carrying Bauhaus men—that was the root of everything we did," he recalls, "but we got a lot of ideas from *Domus.*"

Alexander Girard, an architect who had invited Nelson to design a room for his 1949 "Exhibition for Modern Living" at the Detroit Institute of Arts, was commissioned to create colorful fabrics and wallpapers for Herman Miller, a spirited contribution that continued from 1951 into the 1970s. The 1950s were the heyday of Nelson's association with the firm, and he brought in John Pile, an architect turned furniture designer, to take over that side of the business from Farmer.

When Pile arrived in 1951, the office staff numbered only six; when he left, in 1962, there were that many people concentrating on furniture alone, out of a total of twenty to twenty-five. "During my time there, George did not design any of the furniture, but he gave or withheld his approval," Pile recalls. "It was a place where you were permitted to do good work, without interference." He explains that he and his associates would sketch a lot of different iterations, and a few of these would be turned into full-scale mock-ups in Zeeland. Only a few of the prototypes survived evaluation and went into production, and yet one marvels at the diversity of designs that were offered for sale.

"The real assets of Herman Miller at that time," Nelson wrote, "were items one never finds on balance sheets: faith, a cheerful indifference to what the rest of the industry might be up to, lots of nerve, and a mysterious interaction that had everyone functioning at top capacity while always having a very good time. Finally, Herman Miller allowed its designers to help shape its policies and direct its energies in a manner virtually unique in American industrial design."[13] There was no market research, for Nelson was convinced that if he and DePree liked something, there had to be a few thousand other people who would share their opinion.

Luxurious case goods, like the Rosewood Group (1952–57) and the miniature cabinets (1954–63), sustained a tradition of unadorned craftsmanship that had begun with Rohde and reached back to the honest simplicity of the colonial era before the disease of historical revivalism took root. The perfectly matched grains, hand rubbed to silky smoothness; the impeccable detailing and tapered porcelain pulls; and the thin edges that would become the name of a later group of cases (1958–62) all have a timeless beauty—though the company was one of the first to phase out rosewood and other endangered species.

There was a continuing emphasis on practicality. A lightweight tray table (1949) that employs the same principle as Eileen Gray's classic E.1027 table of 1927 has recently been reissued, and the pedestal side table has remained in production for half a century. The Nelson office designed handsome modular seating, steel-framed chairs, and case goods, plus a growing range of contract furniture through the 1950s, but the pieces that drew the most attention—then and today—were quirky and sometimes problematical.

One of Pile's first assignments was to design a chair that would make use of the molded plywood technology that had been developed for the Eames plywood furniture. Nelson suggested a round seat and a "hornlike" back. In 1952 Pile drew a side chair, which was prototyped, approved, and later christened the Pretzel. The high cost (over $100) kept it out of production, and Herman Miller was unable to make the torqued arm that Pile added to give the chair greater resilience. Five years later, production was contracted out to Lawrence Plycraft, which produced about a hundred in both versions but was unable to reach a satisfactory agreement with Herman Miller. Surviving examples of this springy, organic design—as pared-down as Gio Ponti's Superleggera side chair—are cherished, though a simplified version was issued by ICF in 1985.[14]

The 1950s was an era in which the massive, bulbous forms that characterized the previous decade were attenuated, often to a mannered degree. One sees this in the wire chairs of the Eameses and Harry Bertoia; in the slim platform beds supported on hairpin legs and the curvilinear Kangaroo armchair that emerged from the Nelson office; and—most dramatically—in the Swaged-Leg group of 1958–64. According to Pile, Charles Pollack conceived this as a student at New York's Pratt Institute of Design and developed it after joining the office. The name came from the process of tapering and curving the tubular steel of the base. Insect-like in its delicacy—one thinks of a long-

legged spider walking across a room—the chair is surprisingly resilient and comfortable. The fiberglass shell combines seat, arms, and back in two linked pieces (which were available in contrasting tones) and is supported on four branching legs. In one version, the back is separately articulated and tilts. The chairs can be combined with a matching dining table or an elegant desk that is ideal as a place to write and conceal love letters. The Swaged-Leg group would have been more at home in Milan than Michigan, and it enjoyed little success except in Europe.

Another Pratt student who brought his design to the office was George Mulhauser, and Nelson (who was always great with names) christened it the Coconut chair (1955). Michael Darling likens the rounded triangle of its shell to Eero Saarinen's Kresge Auditorium at MIT, and he sees Irving Harper's Marshmallow love seat (1956) as "proto-Pop," anticipating Roy Lichtenstein's use of benday dots in the following decade.[15] The Marshmallow was a brilliant idea that was ahead of its time, aesthetically and technologically, and only a couple hundred were made. Yet it has been recognized as one of the icons of the era, along with Harper's ball clock, and Herman Miller has recently reissued it, (along with the Coconut chair, which is currently manufactured and distributed in Europe by Vitra).

Harper recounts that the Marshmallow was designed in a weekend as a problem-solving exercise, utilizing self-skinned injected plastic cushions that were offered to the office by a Long Island company. Since the cushions had a maximum diameter of twelve inches, Harper used eighteen of them, attached to a steel frame. The design was proto-typed and approved, but the plastics company was unable to provide its invention as specified, and Herman Miller had to produce them, by hand, as upholstered foam cushions on discs of plywood. That drove up the cost and destroyed the rationale of the design.[16]

Nelson became personally involved in projects that had broader implications than single pieces of furniture. As an idealistic architect he dreamed of changing the world, starting with that stubborn survival, the single-family home. Like so many of his contemporaries, from Buckminster Fuller to the Eameses, he explored, with partner Gordon Chadwick, the potential of factory production. His Experimental House, published in *Architectural Record* in December 1957, was an elegant, livable concept comprising aluminum cubes topped with translucent domes. Though critically acclaimed it was never put into production, but Nelson was able to incorporate its qualities of lightness, translucency, and prefabrication into his pavilions for the American National Exhibition of 1959 in Moscow.[17]

That exhibition was the largest single achievement of the Nelson office, an intimidating job of planning and execution that had to be completed in six months. **The United States Information Agency challenged the firm to create the ground-up structures and installation of an 80,000-square-foot showcase for the American way of life at the height of the Cold War. It was a logistical nightmare, but Nelson couldn't refuse and he pulled off a collaborative triumph. Fuller supplied a geodesic dome that housed a mesmerizing seven-screen movie by Charles and Ray Eames, who arrived at the site, film cans under their arms, on the eve of the opening. The Nelson office devised a system of interlocking fiberglass umbrellas and a huge jungle gym for the display of exhibits.** Everyone remembers Richard Nixon's "kitchen debate" with Nikita Khrushchev and infers a confrontation, but the exhibition was wildly popular, attracting three million Russians in six weeks and subverting preconceptions on both sides of the ideological divide.

Meanwhile, Nelson and his associates were developing more modest storage structures for the American market. The Omni system comprised spring-loaded square-section

aluminum poles supporting shelves, desktops, and cabinets, and was developed in 1956 for William Dunlap's Aluminum Manufacturing Company, an hour's drive from Zeeland. Herman Miller was offered distribution rights but declined and then insisted that Nelson devise a competing system for them. This was introduced the following year as the Comprehensive Storage System, using flat rather than square-section aluminum poles, which made it more elegant but less versatile. It was a logical outgrowth of Storagewall and the freestanding Struc-Tube system of 1948, and though designed primarily for residential use, it proved too costly and austere for most homeowners. Its future, and that of many similar systems, was in the contract market, which underwent explosive growth during the next few decades.

In a 1958 report Nelson asserted: "It is our belief that the manufacture and sale of furniture for home use is no longer an important part of the Herman Miller business."[18] However, he urged that the residential market was worth holding onto to balance swings of demand in the contract field and argued that the one fed into the other: "A man who has an Eames lounge chair in his home is more prone to suggest EOG [Executive Office Group] for his office than one who has no previous knowledge of the company."

Nelson saw the future more clearly than most, and he had looked forward to the day when furniture would become unobtrusively functional, but now he began to feel excluded from the process. In 1960 Robert Propst, an inventor and teacher, was brought in as president of Herman Miller's new research division to respond to the challenge of the open office. The concept was first explored in Germany and was picked up by American firms in the early 1960s. Nelson appointed Ronald Beckman, who succeeded Pile in 1962 as chief furniture designer, to incorporate Propst's recommendations into the first Action Office system. Launched in 1964, it was judged elegant and inventive but too pricey, and Herman Miller sidelined Nelson as the friction between him and the researcher spilled into the open. He felt "as though I had been ordered out—Propst

dominates the show. He's very able and inventive, but I don't like him."[19] The estrangement led him to develop a system he felt was more humane for the expansive offices of the Lutheran Aid Association, an idealistic insurance corporation.

The bond of mutual trust between Nelson and D. J. DePree lasted to the end, but Hugh DePree, who took over from his father as CEO in 1962, was never as close. Later he reflected: "George . . . thought so clearly, so easily, so quickly about so many subjects that it was difficult for him to bring projects to completion. He seemed to lack discipline, especially during the waning years of our relationship. . . . Nevertheless, working with him was always a joy and at times breathtaking."[20]

There were larger reasons than the change of CEO and the growing competitiveness of the industry. Nelson offered an explanation: **"In the forties and fifties when Charlie Eames and I were going like gangbusters—and a lot of other people, too—we were young, and the climate was not as disturbing as it has become since. The war had gotten resolved and now we were going to have peace and prosperity. All the things that showed up to bother us, like pollution, ecological and energy problems, and the decay of the city, were over the hill."[21]**

Confronted with this grim reality, Nelson became the Savonarola of the design world. "For two years I've been saying—a voice in the wilderness—that we must start designing out the overkill in all the products," he told D. J. DePree in 1982. "If you've got a partition that's supported on 60 pounds of diecast aluminum this is an outrageous way to use a material that is being depleted and uses a lot of energy to produce."[22]

In his provocative introduction to *How to See*, subtitled *Visual Adventures in a World God Never Made*, Nelson declared "most people are visually illiterate—hence the visual squalor of the contemporary environment." He blamed "the accelerating tendency of a technological society to turn its people into things," emphasizing words and numbers at the expense of seeing.[23] In his masterly

sequence of black-and-white images, derived from another educational slide show, Nelson reveals his brilliance as a photographer and as an observer—of junkyards, historic cities, and much in between.

His introduction to *How to Wrap Five Eggs*—a classic anthology of traditional Japanese packaging—prompted him to praise a society in which "a complete man could no more tolerate the sight or touch of a wrongly made thing than could Nature." In contrast, "we have brainwashed ourselves into equating the new with the good, the newest with the best, and the only remaining holes in the synthetic padding wrapped around our uneasy conviction are those intermittent fits of modernistic anxiety, so often expressed in nostalgic fads."[24]

Designs for products, interiors, and furniture continued to flow out of the Nelson office in the last two decades of his life. Some were distinguished: a typewriter for Olivetti-Underwood and the New York Studio-Haus for Rosenthal (both in 1968); the graphics and interior for La Potagerie, a trendy Manhattan restaurant (1970); the ergonomically advanced light office chair for Herman Miller (1971) and a work-station prototype for Workspaces (1976); and even a design for a chair that could be fabricated in prison workshops (1977). But much of the magic had fled, as it had in the contemporary productions of the Eames Office.

For Nelson, as for the Eameses, the last major project was an exhibition; his was "Design Since 1945" at the Philadelphia Museum of Art in 1983. In the catalog he wrote: **"The aim of the design process is always to produce an object that *does something*. In problem solving, the limitations are far more important than the freedoms. . . . The only creative freedom that is worth anything is found in set-ting up a problem so that it can be solved intelligently."**[25] It's a fine epitaph for an exemplary life in design.

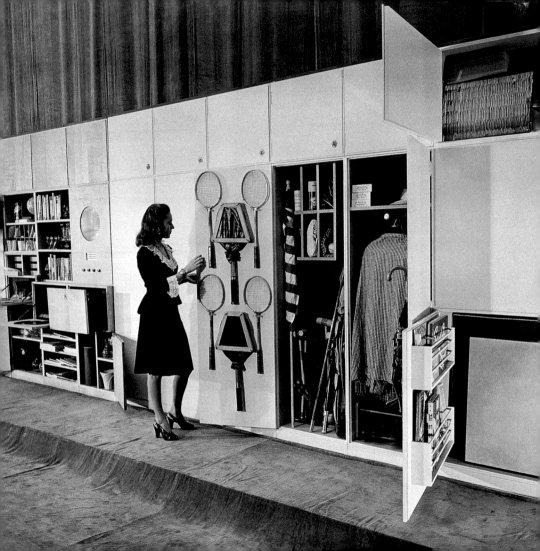

Nelson's Storagewall expanded the ordinary cavity wall to contain all the impedimenta of daily life. This seminal design was published in *Architectural Forum*, and later in a splashy *Life* feature, provoking wide public interest and intense hostility from the furniture trade press, which feared that the invention could ruin the case-goods industry.

 STORAGEWALL, 1945

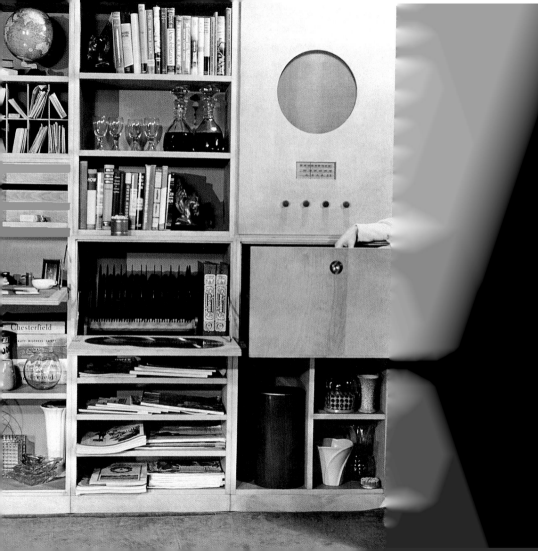

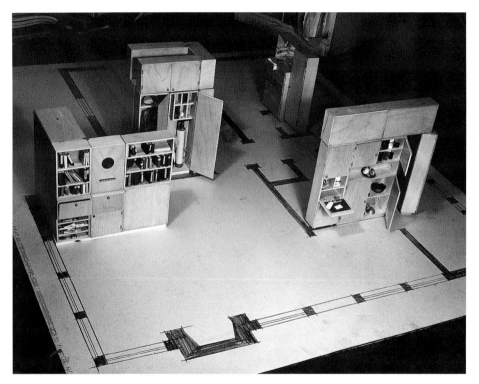

STORAGEWALL AND MINIATURE MODEL,
1945

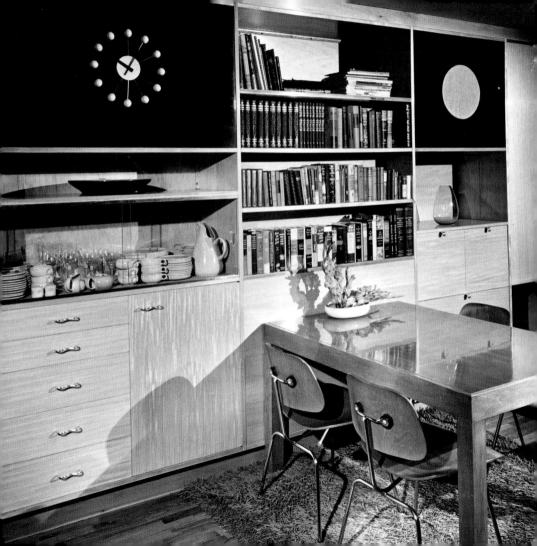

* BASIC STORAGE UNITS WITH BALL
CLOCK AND EAMES DCM CHAIRS
FOR HERMAN MILLER, c. 1950

* BASIC STORAGE IN HUGH DEPREE'S
OFFICE, c. 1950

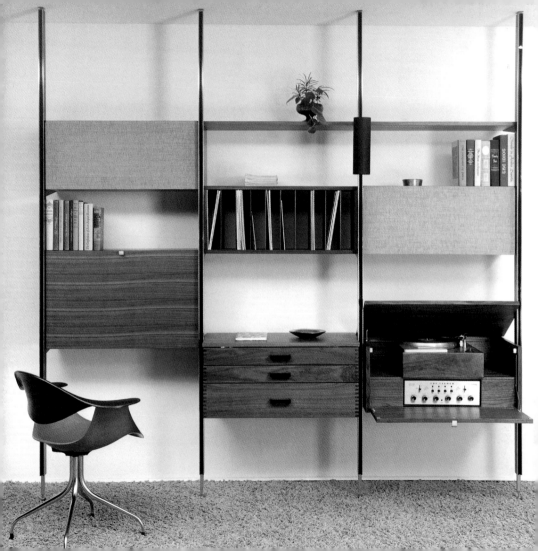

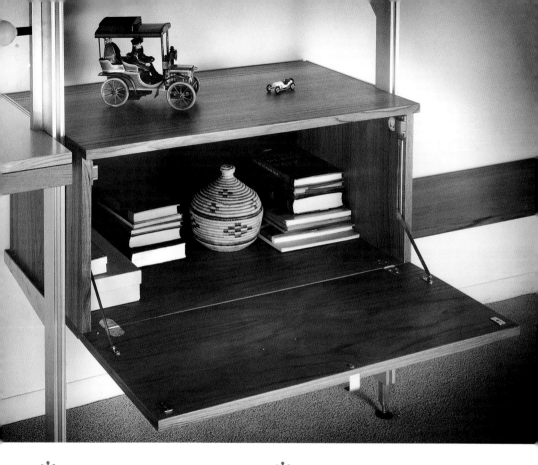

※ CSS (COMPREHENSIVE STORAGE SYSTEM)
FOR HERMAN MILLER, 1959

※ CSS WITH DROP FRONT STORAGE UNIT
FOR HERMAN MILLER, 1965

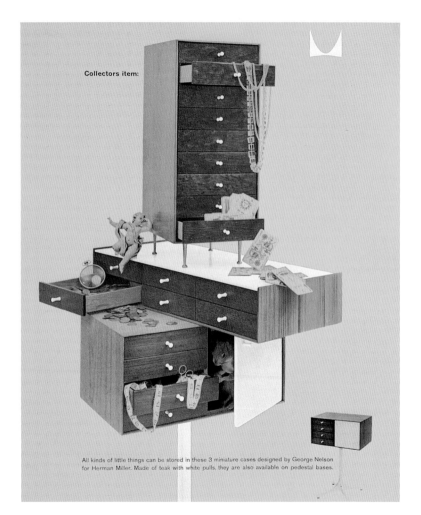

Collectors item:

All kinds of little things can be stored in these 3 miniature cases designed by George Nelson for Herman Miller. Made of teak with white pulls, they are also available on pedestal bases.

As design director for Herman Miller, and later as an outspoken consultant, Nelson found what he called "a glorified cabinet shop" and helped make it an industry leader, a powerhouse of modern residential and contract design.

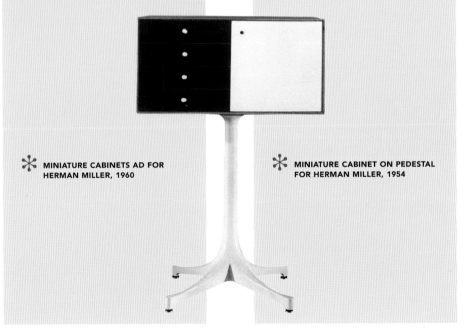

✳ MINIATURE CABINETS AD FOR
HERMAN MILLER, 1960

✳ MINIATURE CABINET ON PEDESTAL
FOR HERMAN MILLER, 1954

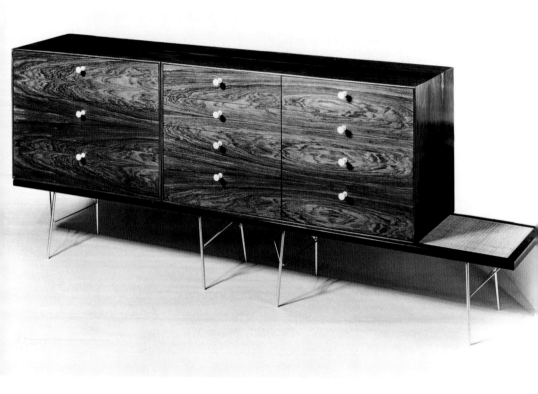

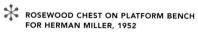

**ROSEWOOD CHEST ON PLATFORM BENCH
FOR HERMAN MILLER, 1952**

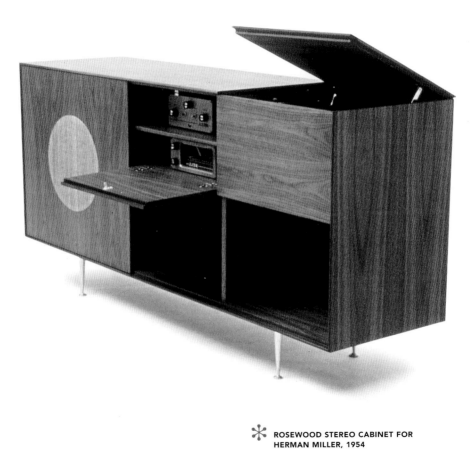

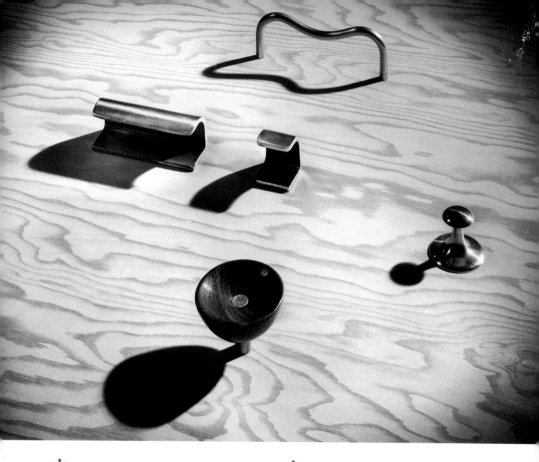

✳ FIVE DRAWER PULLS DESIGNED FOR BASIC
CABINET SERIES, c. 1946

✳ BASIC CABINET WITH STEEL HAIRPIN LEGS
FOR HERMAN MILLER, 1954

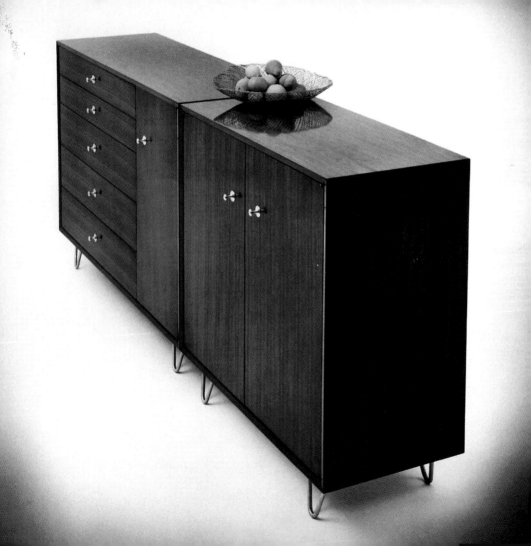

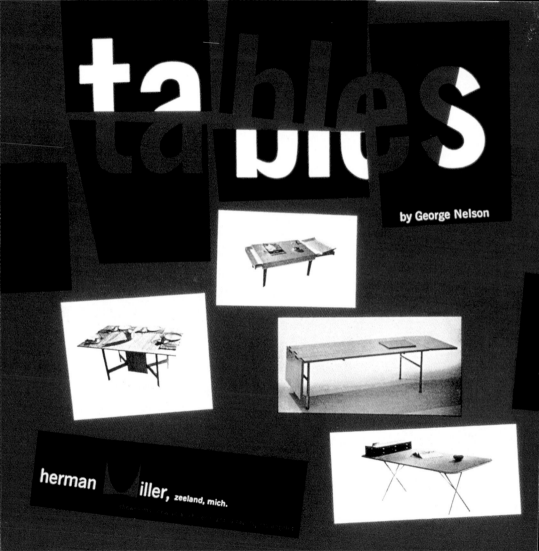

tables

by George Nelson

herman Miller, zeeland, mich.

Most of Nelson's early designs were simple case goods, chairs, and tables, which required no special tooling or technical skills, but each piece was made available in a variety of sizes, woods, and finishes. His overriding concern was to eliminate waste, and many pieces have a Shaker-like simplicity and versatility.

TABLE AD FOR HERMAN MILLER,
c. 1956

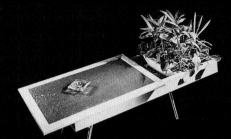

designed by george nelson...built by herman [] iller...a versatile coffee table

The top slides, revealing

a compartment for magazines

and condiments . . . there is also

a generous metal plant box . . .

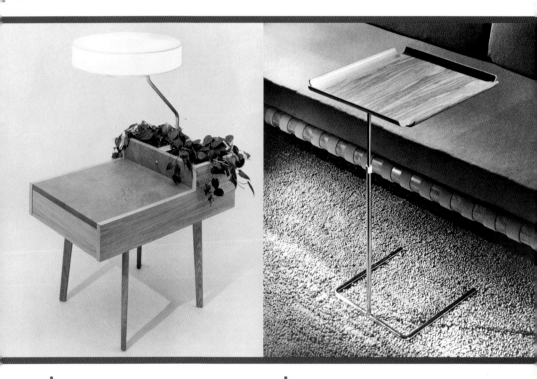

※ SIDE TABLE WITH LAMP AND PLANTER
FOR HERMAN MILLER, 1947

※ TRA-TABLE FOR HERMAN MILLER, 1949

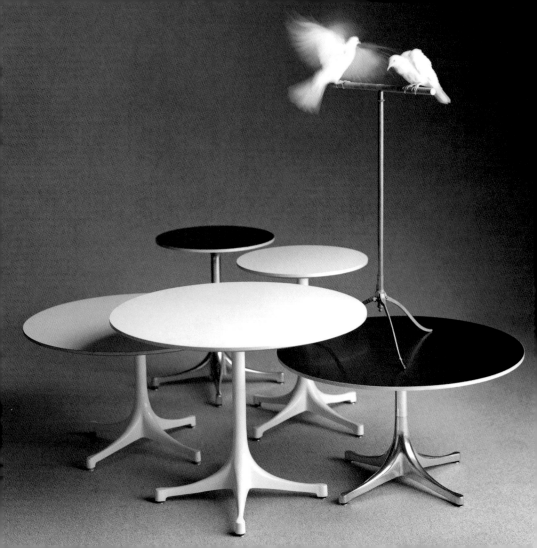

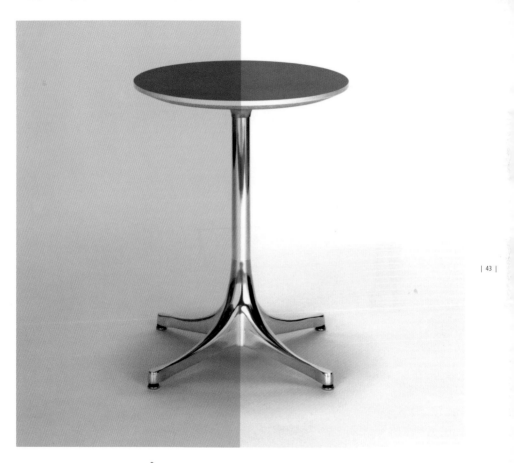

PEDESTAL TABLES FOR HERMAN MILLER, 1953

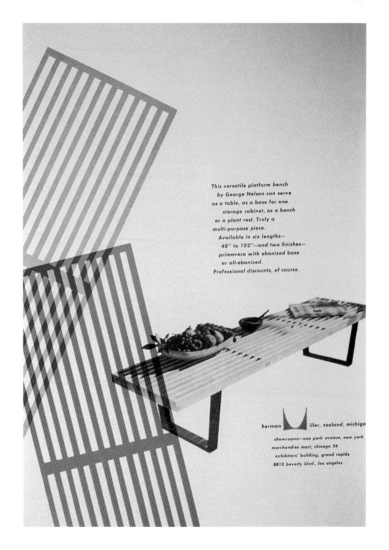

This versatile platform bench
by George Nelson can serve
as a table, as a base for one
storage cabinet, as a bench
or a plant rest. Truly a
multi-purpose piece.
Available in six lengths—
48" to 102"—and two finishes—
primavera with ebonized base
or all-ebonized.
Professional discounts, of course.

herman miller, zeeland, michigan

showrooms—one park avenue, new york
merchandise mart, chicago 54
exhibitors' building, grand rapids
8810 beverly blvd., los angeles

While at *Fortune*, Nelson designed the slatted plat-form bench as a way of deterring callers from sitting in his office for more than fifteen minutes. It failed that test, but became a durable icon; the foundation of another career.

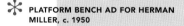

PLATFORM BENCH AD FOR HERMAN
MILLER, c. 1950

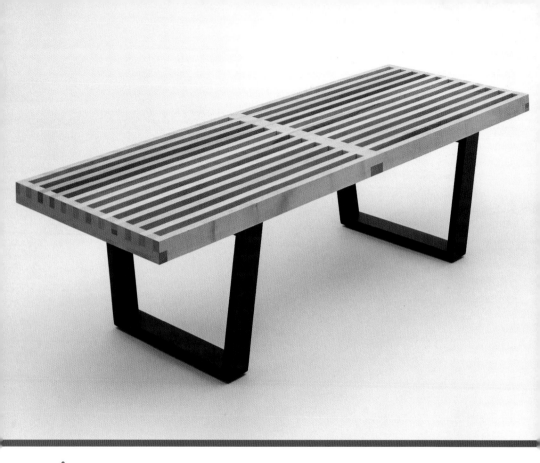

PLATFORM BENCH FOR HERMAN MILLER,
1946

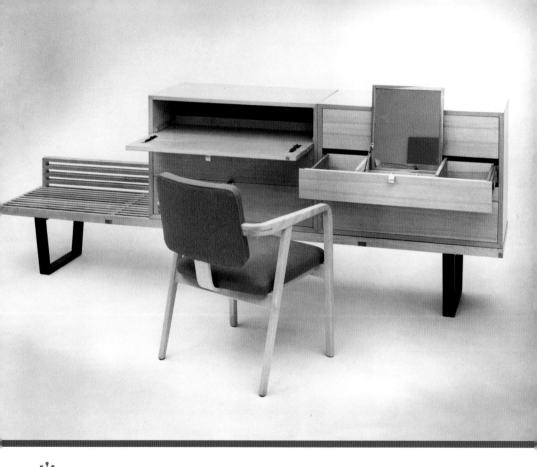

PLATFORM BENCH WITH DRESSING TABLE
FOR HERMAN MILLER, 1948

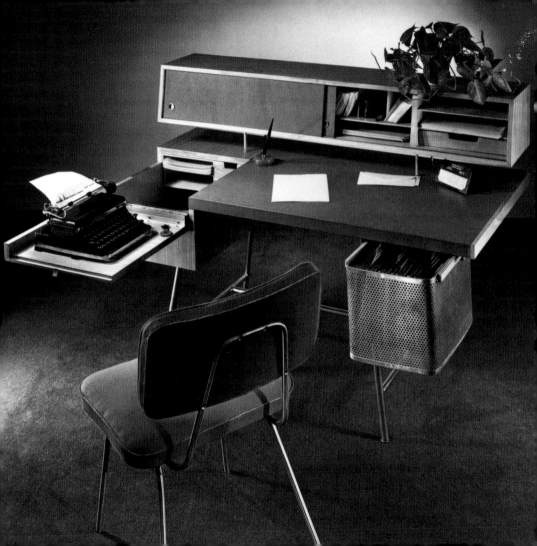

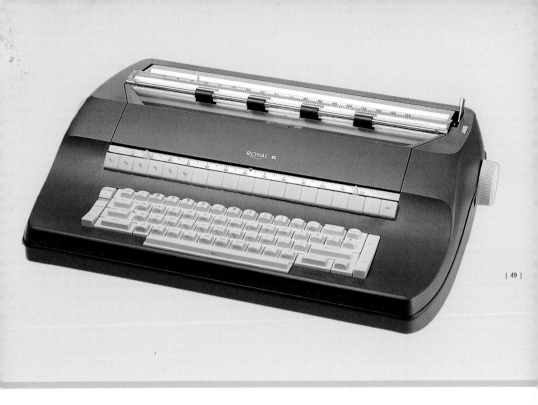

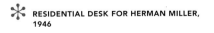 **RESIDENTIAL DESK FOR HERMAN MILLER,**
1946

✳ **TYPEWRITER FOR ROYAL MCBEE, 1961**

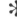 EOG (EXECUTIVE OFFICE DESK WITH
LAMP) FOR HERMAN MILLER, 1952

SWAGED-LEG DESK AND CHAIR
WITH ALEXANDER GIRARD FABRIC
FOR HERMAN MILLER, 1958

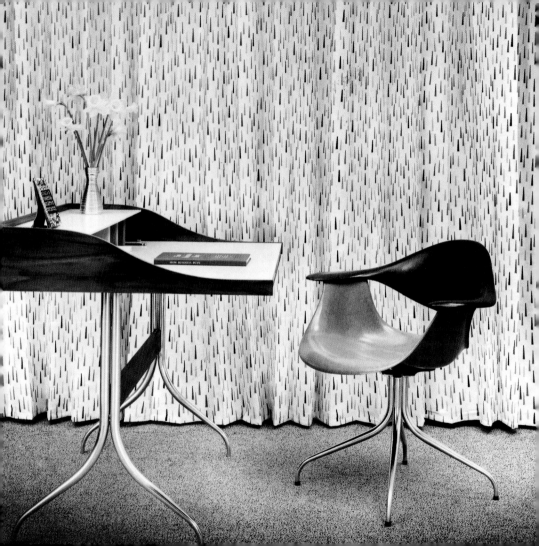

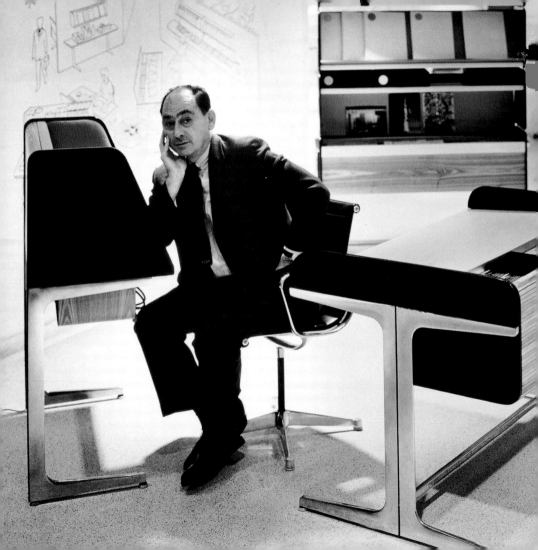

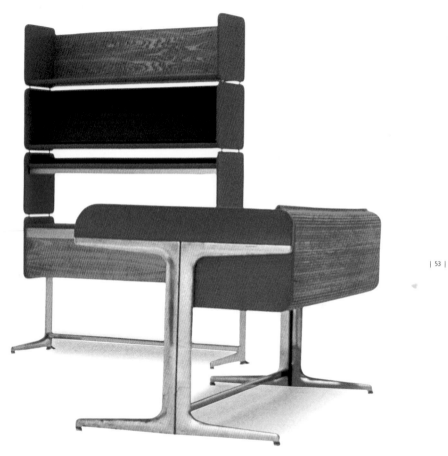

NELSON (SITTING ON AN EAMES CHAIR)
AND THE ACTION OFFICE SYSTEM FOR
HERMAN MILLER, 1964

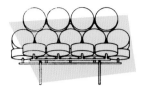

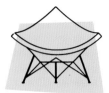

Nelson wrote a statement of principles for the first Herman Miller catalog: "What you make is important. Design is an integral part of business. The product must be honest. You decide what you want to make. There is a market for good design."

✳ DALLAS SHOWROOM AD FOR HERMAN
MILLER, 1955

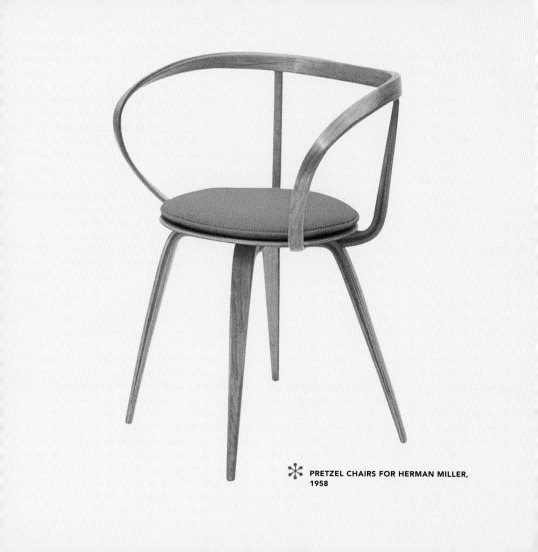

PRETZEL CHAIRS FOR HERMAN MILLER, 1958

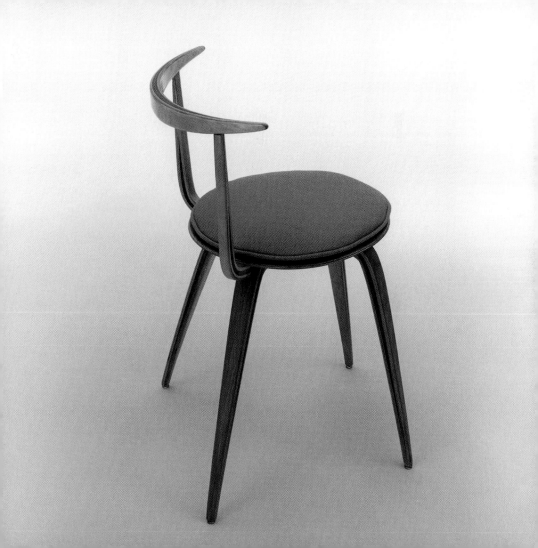

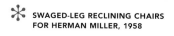 **SWAGED-LEG RECLINING CHAIRS
FOR HERMAN MILLER, 1958**

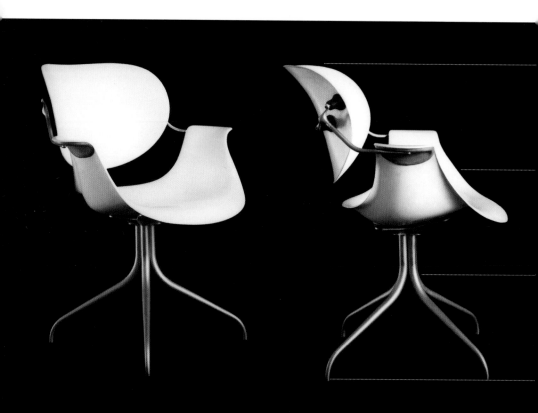

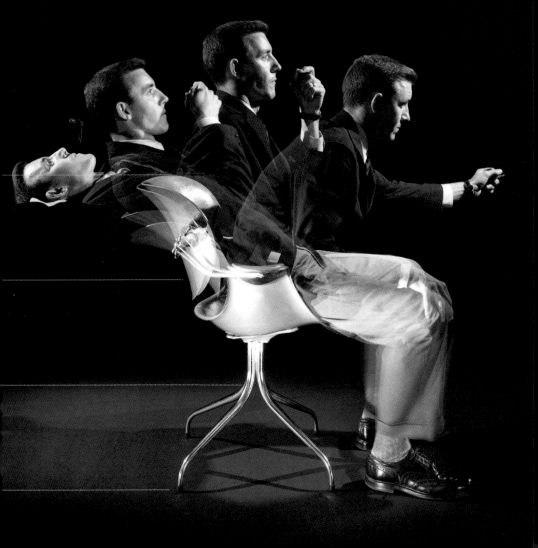

※ CHAISE AD AND CHAISE FOR HERMAN
MILLER, 1954

※ DAYBED FOR HERMAN MILLER, 1954

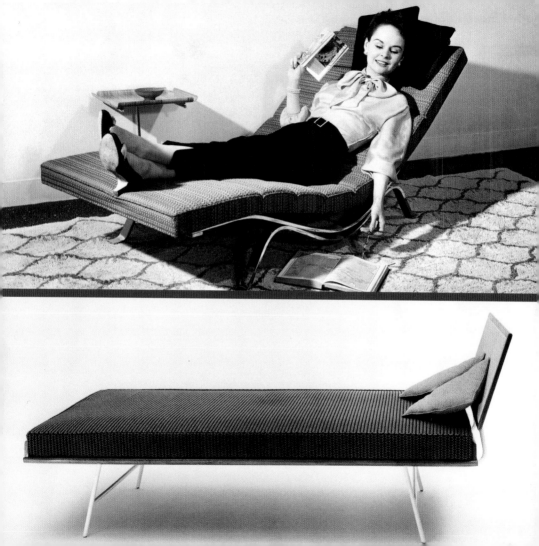

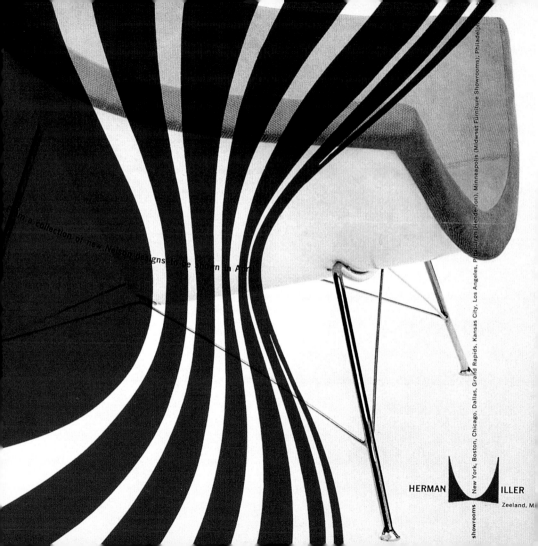

in a collection of new Nelson designs to be shown in April

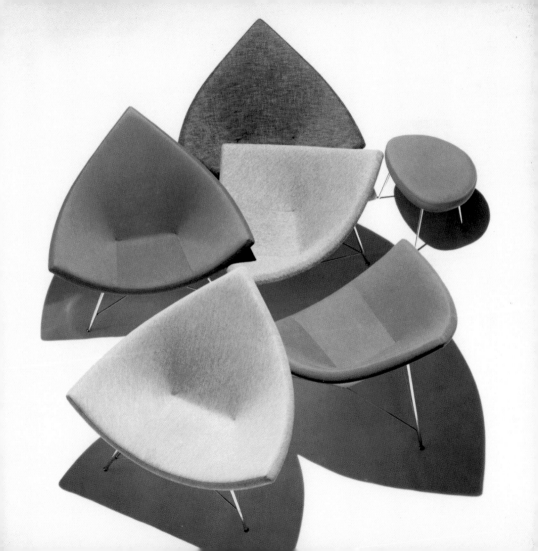

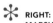 PREVIOUS PAGES: (LEFT)
COCONUT CHAIR AD FOR
HERMAN MILLER, c. 1956

PREVIOUS PAGES: (RIGHT)
COCONUT CHAIRS AND
OTTOMAN FOR HERMAN
MILLER, 1955

RIGHT:
MARSHMALLOW LOVE
SEAT FOR HERMAN
MILLER, 1956

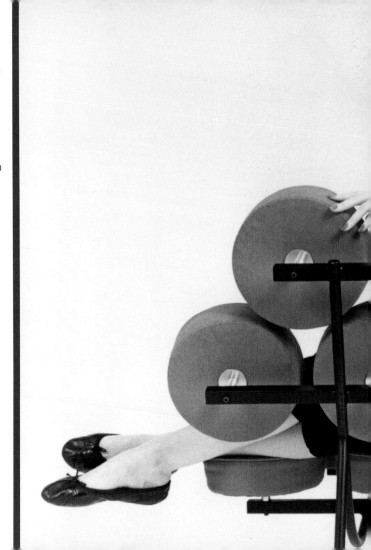

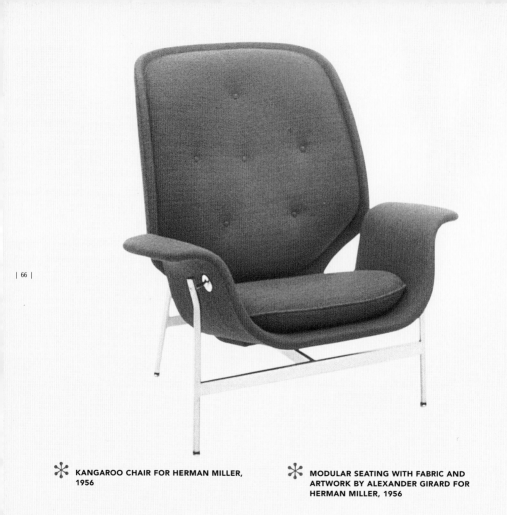

✳ KANGAROO CHAIR FOR HERMAN MILLER,
1956

✳ MODULAR SEATING WITH FABRIC AND
ARTWORK BY ALEXANDER GIRARD FOR
HERMAN MILLER, 1956

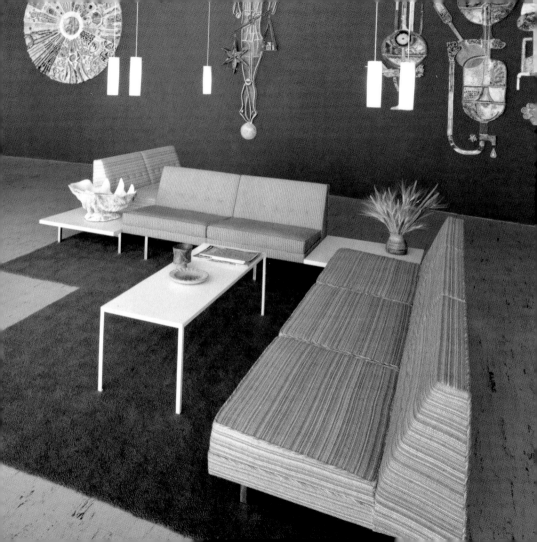

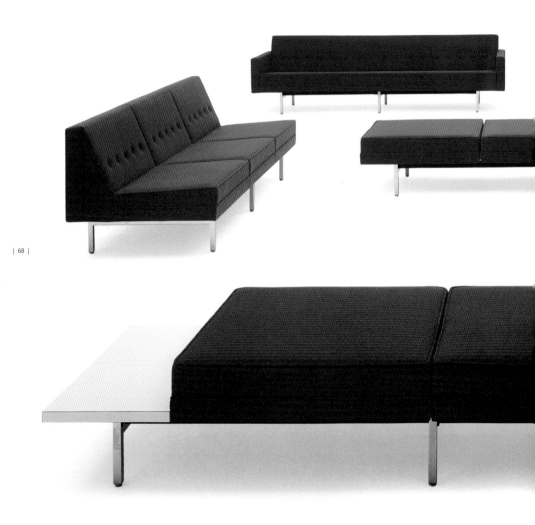

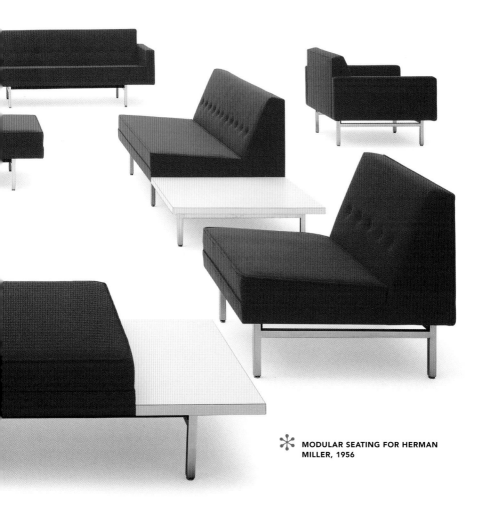

* MODULAR SEATING FOR HERMAN
 MILLER, 1956

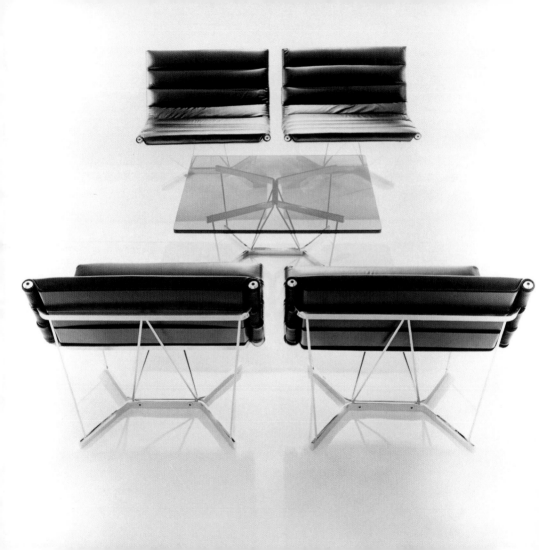

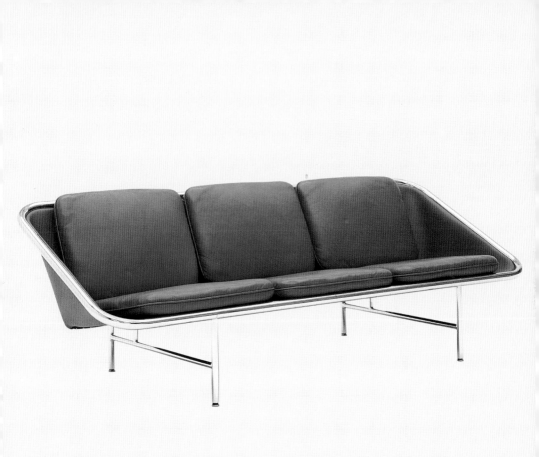

✳ CATENARY CHAIRS AND TABLE
FOR HERMAN MILLER, 1963

✳ SLING SOFA FOR HERMAN MILLER,
1964

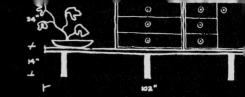

announcing the Opening of the ne[w]

herman **M***iller* showroo[m]

and the first complete showing
of the furniture collection
designed by George Nelson

4 to 7

Tea • Tuesday, March 25th
One Park Avenue • New York City

❋ NY SHOWROOM OPENING INVITATION
FOR HERMAN MILLER, 1947

❋ HERMAN MILLER'S NY SHOWROOM,
1950s

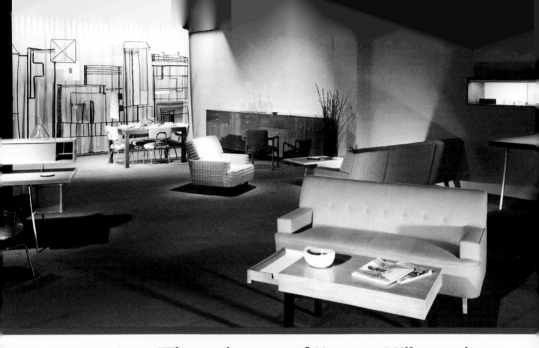

"The real assets of Herman Miller at that time," Nelson wrote, "were items one never finds on balance sheets: faith, a cheerful indifference to what the rest of the industry might be up to, lots of nerve, and a mysterious interaction that had everyone functioning at top capacity while always having a very good time."

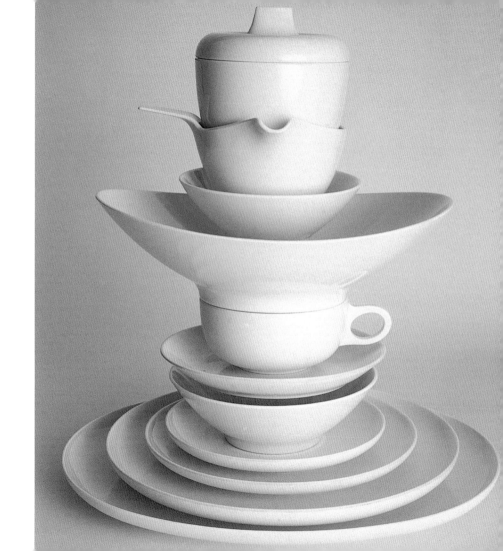

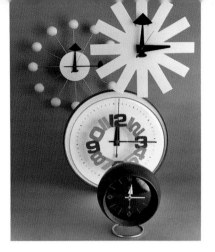

* FAR LEFT: PROLON MELAMINE DINNER-
WARE FOR PRO-PHY-LAC-TIC BRUSH
COMPANY, 1952

* VARIOUS CLOCKS AND KITE CLOCK FOR
HOWARD MILLER CLOCK COMPANY, 1950s

As head of his own design office
Nelson handpicked brilliant talents
and gave them the freedom to
develop his ideas in their own
way and to work independently on
the design of furniture, graphics,
clocks, lamps, exhibitions, interiors, an
experimental house, and much else.

* FOLLOWING PAGES: (LEFT) FOUR DESK
CLOCKS FOR HOWARD MILLER CLOCK
COMPANY, 1950s

* FOLLOWING PAGES: (RIGHT) SUNBURST,
STAR, ASTERISK, AND BALL CLOCKS
REISSUED BY VITRA, 1999

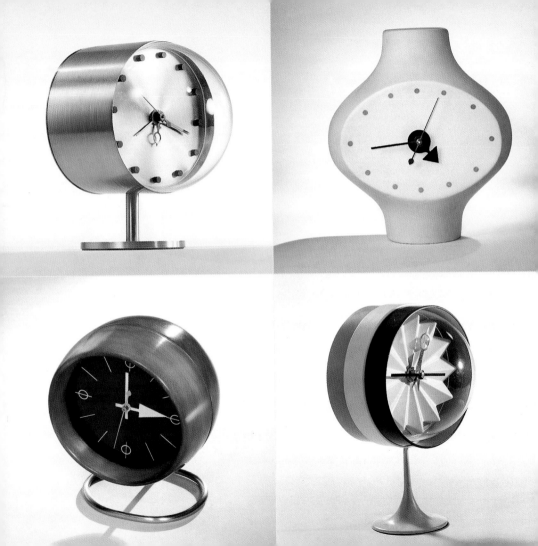

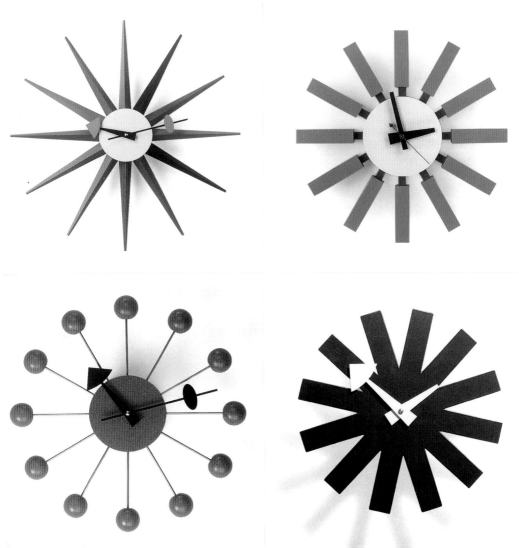

ПРОМЫШЛЕННАЯ
ЭСТЕТИКА США

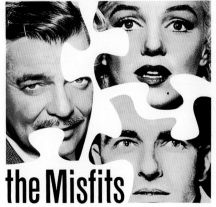

| 79 |

FAR LEFT: LOGOS FOR HERMAN MILLER (1946), CREATIVE PLAYTHINGS (1968), AMERICAN EXPRESS (1961), EVERBRITE ELECTRIC (1960), AND THE AMERICAN NATIONAL EXHIBITION IN MOSCOW (1959)

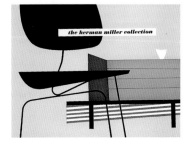

POSTER FOR *MISFITS* (1960); BROCHURE/ADVERTISEMENT FOR HOWARD MILLER CLOCK COMPANY (1963); CATALOGS FOR HERMAN MILLER (1950s)

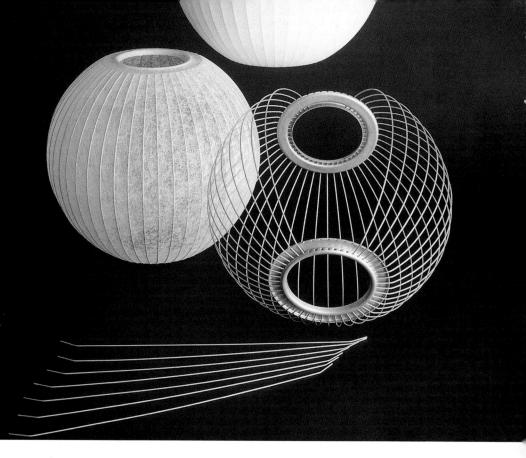

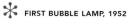

✳ FIRST BUBBLE LAMP, 1952

✳ LATER VERSIONS AND SHAPES OF THE
BUBBLE LAMP FOR HOWARD MILLER
CLOCK COMPANY, 1953–1960

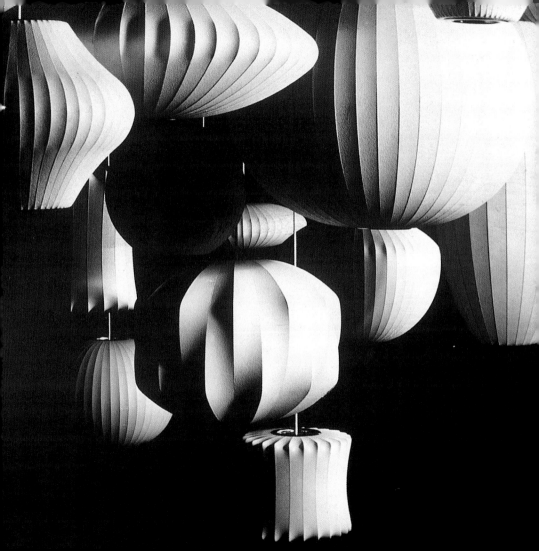

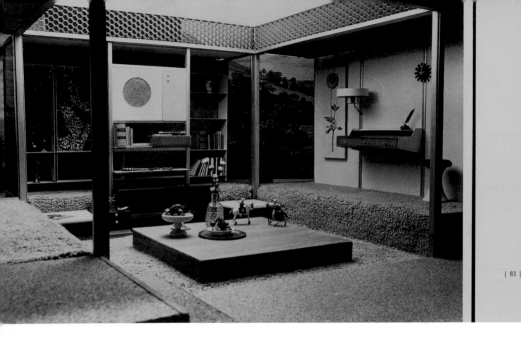

Nelson's Experimental House, published in *Architectural Record* in December 1957, was an elegant, livable concept comprising aluminum cubes topped with translucent domes.

EXPERIMENTAL HOUSE MODEL, DRAW-
INGS, AND INTERIOR MOCK-UP, 1957

✳ "JUNGLE GYM" STRUCTURE FOR THE
AMERICAN NATIONAL EXHIBITION OF 1959
IN MOSCOW

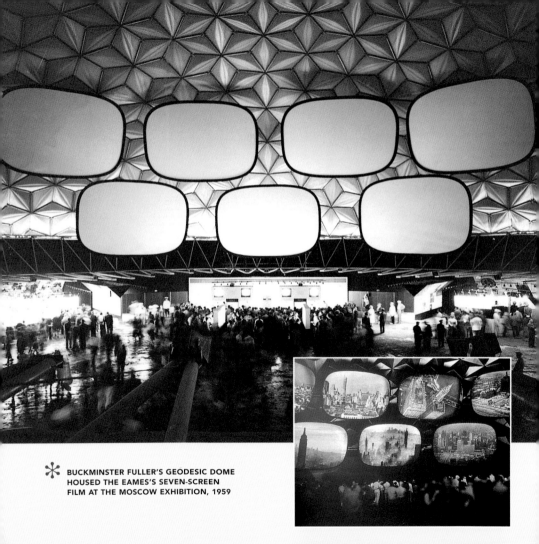

✳ BUCKMINSTER FULLER'S GEODESIC DOME
HOUSED THE EAMES'S SEVEN-SCREEN
FILM AT THE MOSCOW EXHIBITION, 1959

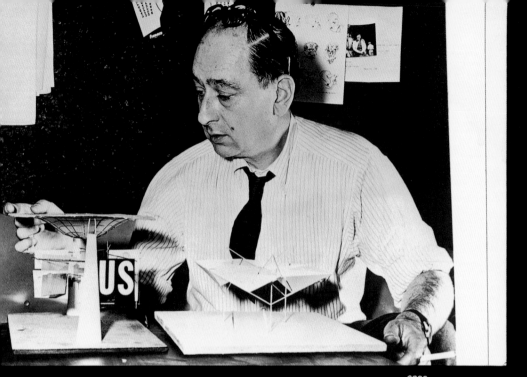

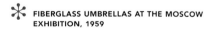

NELSON WITH EARLY MODELS OF THE
UMBRELLA PAVILION, 1959

FIBERGLASS UMBRELLAS AT THE MOSCOW
EXHIBITION, 1959

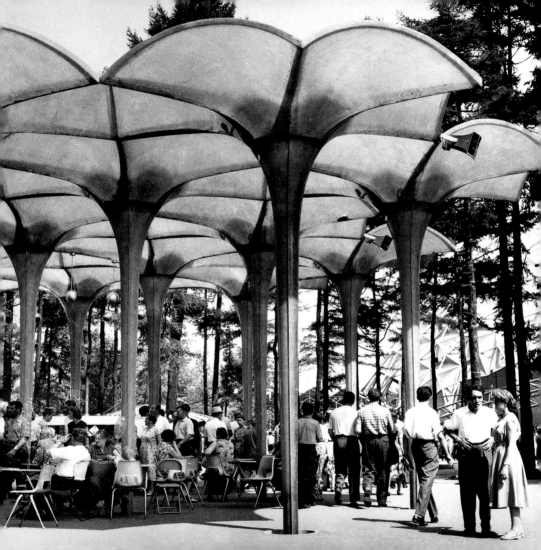

✳ ROSENTHAL STUDIO-HAUS STORE IN
NEW YORK, 1968

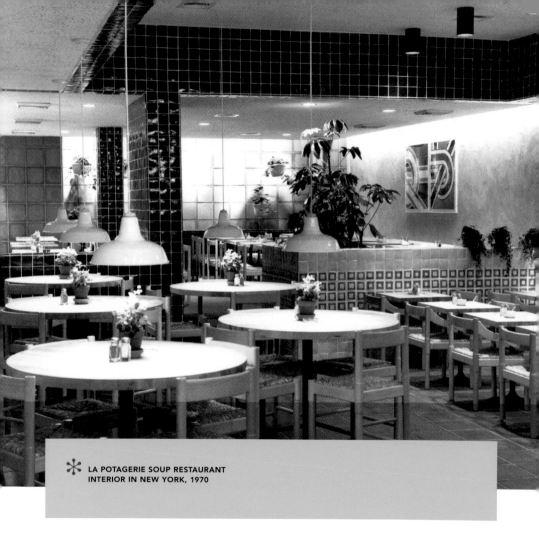

LA POTAGERIE SOUP RESTAURANT
INTERIOR IN NEW YORK, 1970

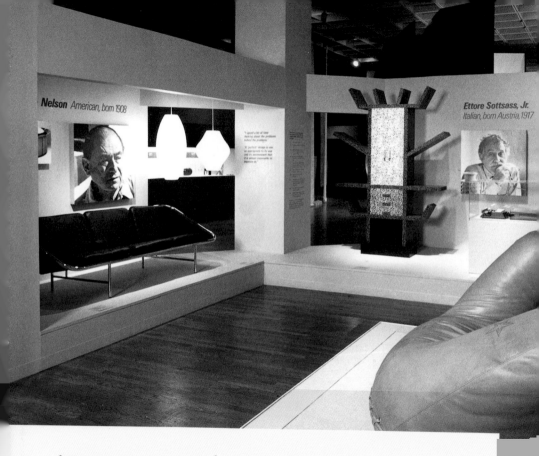

Nelson American, born 1908

Ettore Sottsass, Jr.
Italian, born Austria, 1917

✳ "DESIGN SINCE 1945" EXHIBIT AT THE
PHILADELPHIA MUSEUM OF ART, 1983

✳ FOLLOWING PAGE: (LEFT)
GEORGE NELSON, 1962

GEORGE NELSON BIOGRAPHY

1908 Born May 29 in Hartford, Connecticut, to culture-loving parents of Russian-Jewish descent

1928 Graduates from Yale University with a degree in architecture

1932–34 Wins Rome Prize for study at the American Academy in Rome

1933 First marriage, to Frances Hollister

1935–49 *Architectural Forum,* initially as staff writer and associate editor; co-managing editor, 1943–44; consultant, 1944–49. During this time, he also contributes to *Fortune,* a sister magazine

1936–41 Practices architecture in partnership with William Hamby

1940 Designs innovative New York house for Sherman Fairchild

1944 Conceives Storagewall with Henry Wright

1945 Co-authors *Tomorrow's House* (Simon & Schuster) with Henry Wright

1945–72 Design director, Herman Miller Inc. In the first 18 months he contributes, with Ernest Farmer, an 80-piece collection of wood furniture, and brings Isamu Noguchi and Charles and Ray Eames to the firm

1947 Establishes his first design office in New York. Irving Harper becomes his principal associate with primary responsibility for the design of graphics, furniture, clocks, and other products.

1948–56 *Interiors* contributing editor

1949 Designs interior and catalog for "Exhibition on Modern Living" at the Detroit Institute of the Arts, forging a long association with Alexander Girard

1951–57 Develops, with Gordon Chadwick, design for the Experimental House

1952 Writes *Living Spaces* (Whitney Publications)

GEORGE NELSON BIOGRAPHY (CONTINUED)

1953 Writes *Chairs and Display* (Whitney Publications)

1954 Writes *Storage* (Whitney Publications)

1957 Writes *Problems of Design* (Whitney Publications)

1959 Supervises design of American National Exhibition in Moscow

1960 Second marriage, to Jacqueline Wilkenson

1965–1986 Member and sometimes chair, board of directors, International Design Conference, Aspen. During these years he heads a highly productive office, yet finds time to teach, lecture, and write

1977 Creates *How to See: Visual Adventures in a World God Never Made* (Little, Brown)

1979 *George Nelson on Design* (Whitney Publications)

1983 Creates, with Kathryn Heisinger and others, "Design Since 1945" at the Philadelphia Museum of Art

1986 Dies, March 5, in New York

NOTES

All quotations are from interviews conducted by the author and from comments submitted for this publication, except:

1. George Nelson, conversation with D. J. DePree (Zeeland, Mich.: Herman Miller Archives, 1982).

2. Michael Darling, "Ambient Modernism: The Domestic Furniture Designs of the George Nelson Office, 1944–63" (unpublished thesis, University of California Santa Barbara, 1997).

3. Nelson, interview with Mildred Friedman (Zeeland, Mich.: Herman Miller Archives, 1974).

4. D. J. DePree, memo to Jim Eppinger (Zeeland, Mich.: Herman Miller Archives, November 29, 1944).

5. Nelson, The Herman Miller Collection (Zeeland, Mich.: Herman Miller Archives, 1948).

6. Nelson, interview with Ralph Caplan (Zeeland, Mich.: Herman Miller Archives, 1981).

7. Nelson, "The Furniture Industry," Fortune, January 1947.

8. D. J. DePree, videotaped staff briefing (Zeeland, Mich.: Herman Miller Archives, 1979).

9. Nelson, interview with Caplan.

10. Nelson, Introduction to Design Quarterly 98/99, 1975.

11. Nelson, The Herman Miller Collection, 1948.

12. "Peak Experiences and the Creative Act," Aspen Design Conference, 1977; reprinted in George Nelson on Design (New York: Whitney, 1979).

13. Nelson, Design Quarterly 98/99.

14. John Pile, notes on the history of Herman Miller 5890 and 5891 chair, 1990.

15. Darling, "Ambient Modernism."

16. Paul Makovsky, "Vintage Modern," Metropolis, June 2001.

17. Stanley Abercrombie, George Nelson: The Design of Modern Design (Cambridge, Mass.: MIT Press, 1995), p. 81.

18. Nelson, Report to D. J. DePree (Zeeland, Mich.: Herman Miller Archives, December 1958).

19. Nelson, interview with Friedman.

20. Hugh DePree, Business as Unusual (Zeeland, Mich.: Herman Miller, 1986).

21. Nelson, interview with Friedman.

22. Nelson, conversation with D. J. DePree.

23. Nelson, How to See (Boston, Mass.: Little, Brown, 1977).

24. Reprinted in George Nelson on Design.

25. Nelson, Design Since 1945 (New York: Rizzoli, 1983).

PHOTO CREDITS

Courtesy of Herman Miller, Inc.

pp. cover, 1, 2, 3, 4, 6, 8 (all except clock), 28, 29, 30, 31, 32, 33, 34, 35, 36, 37, 38, 40, 41 (all), 42, 43, 44, 46, 47, 48, 50, 51, 52, 53, 54, 55, 56, 57, 58, 59, 60, 61 (all), 62, 63, 64–65, 66, 67, 68–69, 70, 71, 72, 73, 78 (HM logo), 79 (HM catalog covers)

George Nelson Archives; courtesy of Vitra

pp. back cover, 8 (clock), 24–25, 26, 27, 49, 74, 75 (all), 76 (all), 77 (all), 78 (all except HM logo), 79 (Misfits poster and Howard Miller brochure), 80, 81, 82, 83, 84, 85, 86, 87, 88, 89, 90, 91, 92

Will Brown

p. 92

Norman McGrath

pp. 9, 90

Midori

p. 76 (all)

Rooks

p. 61 (daybed)

Ezra Stoller

pp. 58, 73

INDEX

All products designed for Herman Miller unless otherwise noted.